THE Flower YOU ONCE HELD

THE
Flower
YOU ONCE HELD

WRITTEN BY:

AFTON LAIDY JORDAN

Order this book online at www.trafford.com
or email orders@trafford.com

Most Trafford titles are also available at major online book retailers.

Printed in the United States of America.

ISBN: 978-1-4269-6254-7 (sc)
ISBN: 978-1-4269-6294-3 (e)

Trafford rev. 03/24/2011

 www.trafford.com

North America & international
toll-free: 1 888 232 4444 (USA & Canada)
phone: 250 383 6864 ♦ fax: 812 355 4082

Prologue: To the Readers

This collection of poetry is a way that I have expressed myself through painful experiences and trauma. I have comprised a lot of the same style work, yet they will amaze you as each is individually crafted to make you, the readers say, "Holy Crap!"

I chose the title, "The Flower You Once Held", because I felt it would give you something to think about as you read each poem. Maybe you could find your own meaning through my words.

There are very hard experiences that I could not get through unless it was writing that got me past the hurt.

Many chapters will leave you breathless, gasping for air in the midst of my pain, living through it as I was.

I hope that I can give you something to think about and maybe there could be something you can learn as you read through these adventures and roller coasters of feelings. I hope that you will enjoy reading this collection of poetry.

Thank you so much,

Table of Contents

CHAPTER 1:

The Flower You Once Held

^^^^ ^^^^^ ^^^ ^^^^^ ^^^^^
The flower you once held
Is a disaster about to unfold
The sunlight has gone away
The rain is here to stay
My body is weak
I can't go on
For today
Will
Be
Gone
My petals are slowly dropping
My color is slowly turning
In order for me to live
I
Need
Your
Love
My time is running out
A few more days and I'll be out
I will hold on
I will
Fight
For
That Day
When I have light
^^^^^^^^^^^^^^^^^^^^^^^^
^^^^^^^^^^^^^^^^^^^^^^^^^^^^^^^

CHAPTER 2:

Theater

As it hurts inside,
I'll leave the emotional act of tears to the pros in theater,
Wanting love,
I saw in dreams,
In my head,
An illusion equipped one day,
Love I feel now will be returned,
Trying to accept life,
I go through motions only proving I'm a failure,
Smiling,
Like makeup,
It's painted on,
Laughing loud,
I'm only performing an act,
My turn to play my part in the written script,
Words and actions,
Continuing to try and squeeze into them,
Seeing as one day they just might fit me,
Looking at my reflection it's only a costume I wear,

Feelings don't matter,
I push it away,
Yet this one don't like to stay behind the scenes,
Act and act,
It's coming close
An extra,
And soon seen,
Shed my tears release my pain,
Without this feeling,
Wouldn't be reality,
A cartoon character,
Colored in,
Make believe,
Not letting out,
One mess up and I'm booed off stage,
I'm sweating through my mask,
Red curtains open,
ShowTime!
Last scene and it's a surprise
Tired defeated,
No one to applaud me,
I'm transparent,
Chapter at end,
My part I failed,
Fired,
The curtains close,
And it was the curtains to my tired,
Ended life.

CHAPTER 3:

Lost

Blurry visions
Are cast into
A lost soul.
Feet are shifting
helplessly
In an agitated manor.
My reflection dictating
My every move;
As if it were
Another person
Simply portraying
My figure.
I don't even know
Myself.
Planning to hide
In the
Darkness I see
In my eyes,
I cry myself
Into a ball
Of terrified sleep.
Innovations in
My mind
Have caused
Such panic
In my waking
Dreams.
Put me out of
My misery,
I plead

For my sanity.
I'm looking for myself
And finding
No one.
Seeing all there
Is to see and processing
None for memory-
I'm lost.
Trying to find...
Is it me?
...For I am
No longer sure.

CHAPTER 4:

I Hate Me

Reflections of myself casting rainbows onto the wall,
the light bouncing off, and then I fall!

'Cause, as the rays of sun
danced on that blade, seconds it took
as my anger sprayed.

Hatred
enveloped me as I saw myself; consumption of loneliness,
feelings of being unloved.

I looked into my eyes for the very last time,
and at that second I fell so lightly
into the darkness that lightened my ended life.

'Cause as people I fool don't take a second glance,
I always know this fact and the fact I've always-- I hate me!

I'm describing someone I know so clearly,
and I know her best of all.
No one knows this chick, no one knows her
like me, 'cause I'm the chick.
I'm that person I know; and these are her feelings,
her emotions that don't stop just there.

She hates herself in more ways than one, she and I.
So much to say before I choose to die!

So I'll say it in the only way I know,
in only one way-- I hate me!

CHAPTER 5:

Speaking Statistically

Flowingly, steadily, dreadly, heavily,
My mind broke down, confused, it's deadly.

Take it out on myself I engraved this melody,
Stop abrupt, OCD - suicidal and grown in me.

Thoughts holding me down, picking it up, cravings so beautifully.
Intoxication's my body, adrenaline's now accusin' me.

Frequently, suddenly, unquitingly, increasingly,
killing the pain that's inside, it's taking over me.

Drip, drip, drip. it's so pleasantly inviting, and caressing me,
warmth on my mind, my body, and over intentionally.

Fanatically, excitedly, losing my mind,
mental madness, and so increasingly.

Hearts beating so rapidly, over exhaustion,
I'm so confident, feelings inside of me.

Eating me up violently, physically, banquetly,
losing control so emptily, angrily, and so pathetically aggressively.

You opened up the pain like a bag, you're using me,
re- using me, abusing me, and it's a conclusion to be.

Suicide's only a thought, irrationally, and now I'm able to flee...
Speaking statistically!

CHAPTER 6:

Ten Out Of Ten

Bullets, they come and go
A shot to your head
Death took your life
Gone with the flow.

Robberies, dishonesties
Bags full of cash and I'm out the door
Living in filth now I'm gonna die in riches
As you be showing off in all of its galore.

Enemies stay popping off and they're asking for more
But I'm smoking on the bubble
Speeding with precision
And I'm kicking bitches to the floor.

Because ain't nobody know how to act
When they see a man then they is a whore take a razor to your skin, a buck-fifty
I slice you to the core.

Sleep on me and you is a set-back
My hit's are like blows and they sounding in a roar
Hand me a body bag
Cut you up and be placed inside of your drawer.

Dick cut off and I sent it to the morgue
Unsurprised, your lady, again I say she a whore
Fuckity, fuck, fuck, fuck, she infected you
As you really thought you scored.

Ending this shit because I'm spazin' on you
I'm suddenly bored
Tired of these lyrics so I'm coming out forward
Ten out of ten, Blood is on ma scoreboard.

CHAPTER 7:

My Knife to Your Throat

Darkness creeps around
and it's haunting my thoughts.
Beating the ice air into your head would be bliss.
Hearing you breathe helpless words while you fought,
my laughter in your ears was a mere hiss.
Justice was my knife to your throat a delight.
Humming a melody, I become transparent and fade away.
My soul in happiness took air in flight.
Death took a toll on your life the same day.

CHAPTER 8:

Pain and Sorrow

Longing and desiring,
Wishing, yearning, and craving,
Aching, lusting, and hungry for a lifetime of love.

Affection, worship, and devotion,
hiding, concealing, and covering my pain,
my ache, my hurt, my tenderness, my grief,
my anguish, my torture, my agony, and my sorrow.

Forgetting and overlooking the
facts, the truth, the actuality,
the details and the reality that I am somebody,
I have a name, a purpose, a reason, a point, a function in this world.

In my life, my existence, my time, my days, my
years, and in my being; loneliness, solitude,
isolation, and seclusion have stopped.

Discontinued, ended, and shutdown: my dreams,
thoughts, imaginings, and bright ideas,
but still pain and sorrow will weaken, deteriorate, and decline,
fade, subside, reduce, and lessen once you are one with yourself.

CHAPTER 9:

Only Mortal

I am haunted even as I sleep
for a human has hurt me
and through pictures and frames I creep.
Insomnia keeping me up from dusk till dawn;
wanting peace for myself
my feelings deep throat,
they gag me and I spit as my reflexes are gone.
I dream and conjure,
releasing my spirit into the air.
All that is suddenly felt
is my anger bare.
It's my anger that haunts me,
that has me so hurt,
for that guy that calls himself to be human,
the bridge was built.
But years later,
now it's still burnt.
Control to my body and my mind
for his contract was wrote,
and it was his soul to the Devil
they were confined.
My anger, as it acts as a portal
has me haunted
God, forgive me...
I am only mortal!

My Truth- No Lies

Blank pictures surround the skies
Puffy white clouds swim in the blue of my eyes
Twinkle, twinkle
I pray to the stars as I cry.

The heavens and God above me
none other than the truth, no lie.
For He sent me an angel in form of this guy
A husband, a son, my family, tears of joy I cry.

Rainbow of colors shine down on me
Even as day turns to night it's a new dream to try
No pot of gold at the end of indigo
Just my pride, my joy, my truth- no lies.

CHAPTER 11:

Asking For Suicide

Loving on a Roller-Coaster ride,
I'm loving the only thing on my mind.
The only one in whom I confide;
that silver drip as my life starts to hide.
That razor as I close my eyes.
In the sane world these rules I don't abide,
sentimental feelings loosen and collide.
I'm talking to myself only asking for suicide.

CHAPTER 12:

Bone Fide

Bone Fide
Beautiful are your eyes, so tell me, why do you hide?
Beautiful are your lips, so tell me, why do you not
Place me a kiss?
Beautiful are your fingers, so tell me, why do you
not touch me and caress me?
Beautiful is your body, we should become synchronized.
Portray ourselves as a musical violin,
you be the hard, strong wood frame, me the sensitive,
delicate strings.
Tickle me and let me squirm and sing with musical
hymns.
Let me rub your hard frame, and polish you as I
stroke you up and down.
Vibrations of my strings, lets fornicate.
And never let it be a sin.
Tune in with me, let us become what we could,
together, as one, a whole.
Bone fide... you are beautiful...
so tell me that this; you will not hide.

CHAPTER 13:

Fantasy

Aroused I'm tossing
and turning,
thoughts in my head
keep between my legs burning.

Caught between breaths
as my chest heaves,
hoping to climax,
so finally I can breathe.

He comes in and is
fascinated by my open door,
the wetness has him erect,
and begins knocking at my galore.

Not so fast,
or maybe a little harder I say,
fuck me raw
and don't stop until the next day.

He's behind me,
doggie style,
pulls out
he wants to be in denial.

"Too soon for me...
too early to cum",
then he's back in
and pounding me like a drum.

My sheets are soaked
and my mind's on his dick.
I got a beautiful body
that he continues to lick.

Climax came to my aid,
his touch is what I craved
tonight was not about him, I know
So he stops jerking, isn't he brave?

My fantasy,
isn't it wild?
Not too explicit,
just a bit mild.

Blackness of Red

Thoughts in my head go around and around.
Circled is the rope on my neck, and already bound.
The blood that drips from my blade
How easy is it not to see my pain, and so I fade.
A drip of blood falls as it equals a pool.
Colliding with tears, and death collapses, no longer a fear.
It's military time alright, an hour like a hundred.
The time passes too slow, so I die impatiently.
I awaited the last breath to my lungs, never felt pain after that slice.
Never felt pain as it was never numbed with ice.
Democracy. Hypocrisy.
What happened to my goddamned planned out philosophy?
"No pain, no gain", that's what they always say.
I gained my wish of death, in succeeding suicide.
gained it with pain, and now I see my pride.
Now painless I laid my eyes closed.
Death has taken over...

Dress me up and lay me my box,
make up my face and have me pose.
Just thinking with all these feelings,
maybe just contemplating my next move.
My next step.

In my dream, my tears fall.
And maybe that razor, like an implant will stay lodged.
As my flowing veins; they splatter the blackness of red all around.
Disgusted with myself because none of this can exist.
Reality is life: I'm wanting my blood to flow so fluently,
blackness of red...
Just turn this delicate page, as it's a story of my life
blackness of red
I'm wishing so bad that I was so finally dead!

CHAPTER 15:

A Killer For Life

I'm on my block collecting paper like Jamaica.
People try to stop me, they make it even better.
Blowing up my name so they make themselves deader.
Cruising down the street, I'm in my fire, red Mazda.
I'm looking for the people, they say they flying higher.
Dro in my left, I'm about to roll it up.
Red, orange, yellow hairs, skittles taste the rainbow.
I'm still passing, I'm going to piss in a cup.
FEDs always watch me, but they never stop me.
FEDs on the watch, they try to lock me up.
Two stacks in my hand, I paid those people off.
Bucking in the club, I'm cracking the Grey Goose.
Killers are killers and I'm a killer for life,
Homicidal in my blood,
A lot more then stabbing you, stabbing you with a knife.
Aggression is an occupation and I strive with my life,
Killing you is easy, easier then killing your wife.
You a pussy is pussy and you a pussy for life,
Want to lie on the ground when I'm threatening you with your life.
Because pussy is pussy and I'm a kill a pussy for life,
Homicidal in my eye so you die by the knife.
Because I'm a killer for life.

Razor Take This Pain

Illusions into the life of death...
How I wish it were here for true.
I want my razor to peel through my skin,
(like that of a blade that peels an orange)
I want my razor to become my best friend,
"Quick Silver,
take my pain away."

Justification to my life...
Wouldn't that be death?
Hatred so powerful.
Millions of tears that fall into my towel,
they sink me into nothingness,
"Razor take this pain from me."

My pain has me filled with hurt, physical hurt.
And I pray that the Lord shall convince Death to take me.
("Just take it away!")
Having these urges to free myself from my anguish,
Razor I beg:
"Please take my pain from me."

Cut and let me bleed,
Drip
Drip
Drip
Down.
"Razor take me to death,
and Death, take my pain away."

CHAPTER 17:

Snitching

Snitching people out of the game, it takes a snitch to snitch on,
a snitch to be snitched on. One live saved and two lives gone.
Killing a fight to be right, but I killed 'em 'cause he was wrong.
Putting out my cigarette only to light up my bong.
Bloop, Bloop, Bloop. Racin' and speeding, and now I'm gone.

It's too late to save your life, not even room to have you pass third place with a
medal bronze.
Went into the closet and came out with the fawns. Neck split open and I got your
head hangin' from prongs.

Puff, puff, pass. Laughin' as I'm hearing artificial gongs.
Slowin' down time, killin' brain cells, my mind is gone.

People try to get close, I'm makin' profit, now suddenly they wanna bond.
Pulled out my blade, homicidal, and they life too is now gone.

Bang! Bang! Bang! My bullets comin' full flight speed, they no longer threats, so I
say, "So long".
I don't have time to hold on,
life by life, two, four, six they all gone!

CHAPTER 18:

Hell That Is My Life

I am running down this dark tunnel,
and I have guessed several times,
that it must be my life.
I am trying to scoop my happiness up,
with my hands cupped like a shovel.
I am trying to piece together my life,
but I feel Hell is my life.

Great vindictive eyes follow my breathing,
the fumes of my hot tears collide
with the coldness of my body.
I feel like giving up,
life is torturous as I live it.
I have found my calling from
this Hell that is my life.

I Am My Own Hero

In my heart I hold a fantasy.
I believe a little to escape
the friction of life's stresses.
It feels fantastic to let go of the rape,
the screams in the distant alleys
and the fast motions like a music beat on tape.
I smile today because I have let go.
Maybe my fears were different, but I wear my own cape.

Life's Adventure

Understanding life is
far beyond
the comprehension
of one
being.

Underestimating the
powers that drive
life can be mind
altering and
life changing.

Poetry as one sees
may not be as
one actually
feels,
but represents
in their own state of mind.

Those that are God fearing
or illusive to their own thoughts
and actions
are only hiding
behind a woven mask
of the unknown.

Life is merely
our envisions being
lived out by our
daydreams
and heart desires.

Fraud and
corruption
often take us away from the
path we want to stay
on but
isn't that the art of
mastering
what truly you do not have
power over?

Smell the world outside
and then
smell the world
inside your own head.
Do not the cherries smell
like coffee?

This is a writers' world,
in a writers' head,
on a writers'
page,
is it not?

Then understand that
we are all here
to live
and enjoy
and to learn a little.

Take a letter and make a word
and with
that word
make a conversation...
or maybe even make
life itself an
adventure.

Tears Fall

Colliding together
are my emotions of failure
saddening me.
Shaking with fear, I cry.
I let my tears fall at night,
I try to keep them at
bay during the sunlit hours,
my mind is blurred with pain.
Sorrow sinks into my mind,
and my body.

Tears fall as I hope,
I pray,
and I dream that my own life
will be born in due time.
Hoping this sadness will end,
and this pain I feel will
heal.
God, I plead to you while my
tears fall,
save me from this hurt,
this pain that ceases to end.
Save me from this after effect of
the collision.
My mind races for freedom,
a good nights sleep,
even a comforting flutter inside.
Hurt is inside so deep,
help me to maintain a newly found
river.
One that was made with
my tears that fell
but because of a new birth.
My birth.

Tears fall from my face now,
and it is pain that drives them
to drown the earth.
They fall so fast and hot,
help me, Lord.
I am
hurt so
bad.

CHAPTER 22:

Suicide Myself

You kill me with the words and hits,
and I bleed inside my mind.
I feel so worthless
I feel so down.
I want to take this life
and take it to the end,
so I can bleed to the beat of my pain.
Suicide myself,
these pains in my heart
make me act out of my
character.
Wanting another to give
me what you once did,
I fiend for the love of another.
This pain you give me
with the physical blows,
and the words that make me stay,
have me confused
and I don't know what to do.
My mind is rushing,
I want that blade,
I choose to cut,
I want that bleed,
and the silver to deepen
and slice me to death.
Only then I can win.
This depression I fight,
I choose not to win.

Philosophy

Playing the 'game' we call life,
I have to stay within the lines,
following the rules,
to keep me sane and blind.

The earth spins on its' core
and I've come to learn to listen
to the fascination
of the breaths we take
steadily.

Grieving for the life I may lose,
but isn't tomorrow new?
Creations come when least expected,
and when don't we expect it?

Rolling hills of laughter creep
around the halls
inside of my head.
Happiness seems too funny
to become accomplished.
What life is this?

There is no passion,
without the lust and love I hold
for you,
like that of a trick
or treater bagging candy;
smile!

God gave life,
when we are angered
we take it...
why?
For life is the most precious
gift of all.

And my readers...
what are you anticipating now?
Another stanza?
Another verse?
Maybe some rhymes?
...no, this is just my
look into life...

Philosophy.

Deep In Thought

So much pain lies here in my heart
being prickled too hard, even being the target
that gets hit by the dart.

Lying here, clothe less
I am deep in thought, my mind tries to carry me
to a spot of bliss.

Trying so hard to keep this smile
painted on red, to keep my face perfect
so the evil lurking around doesn't turn me vile.

I am the hurt that you will never understand
my soul and my body, the hurt
combines in one hand.

But I lay here deep in thought,
and bliss is in my own mind,
with money never bought.

So Hurt In My Heart

I feel that I am
So hurt in my heart.
He lights my fire
But lets it burn till
There is nothing left.
Not even ashes to see,
And this fire evaporates
My tears.

I feel that I am
So hurt in my heart.
He says he loves me,
But shows no sympathy
To my cries of pain,
I am so lonely.
I feel there are no
Colored roses,
To go along with
Those hurtful thorns.

I feel that I am
So hurt in my heart.
I have calluses on
My mind from thinking
Of ways to please him.
Trying different ways
Everyday to make him happy.
Massaging my lids
That get no rest.

I feel that I am
So hurt in my heart.
But this drought of tears
Comes closer every night

That I cry myself to sleep.
I am so tired,
Of waiting for the smile
To return back to me.

I feel that I am
So hurt in my heart.
I want him to see my
Watery eyes.
But to see me,
Not only be looking
Past me.
I don't want my
Heart to bleed in
this hurt I feel.

I feel that I am
So hurt in my heart.
I see myself in the
Empty mirror,
And I want to see what
I used to.
I want to see the
Sweetness of his lips
Once again.

I feel that I am
So hurt in my heart.
I am losing my love,
And I wish to find it.
For this hurt I have,
Has only had one face.
And I hurt inside,
Because I love him.
And I no longer see
where that is true
for him to me.

CHAPTER 26:

Death Is My Goal

Find my vein.
Take my pain.
This razor knows how I feel.
Only I know how this pain is so real.
Hot tears fall.
To death I place my call.
Blood from my wrists splatter.
The silver to my skin such a flatter.
Cold kisses of cuts.
I am cutting myself out of a rut.
Rejoice I shall.
My razor is my best pal.
I keep my sworn secrets in
And to death I call with a grin
Calling death with my pain.
Rest I will gain.
Save my soul.
For death is my goal.

Orgasmic Death

Kneeling in my own blood
it's the smell of death that arouses me
touching myself in bliss,
I am overcome with the sensation of floating
the orgasmic smell i get from death
sends me reeling into convulsions,
with vibrations of pleasure.
death has finally taken me for the last time...
for my orgasm was the first...
and this weightlessness is the last!

Sweet Lips Hide Between Thighs

She has invited me in
and her lips are so welcoming,
the warmth that comes from her
makes me sweat with adrenaline.
she's seeping wet and smells so sweet,
I have undressed her lips
of this sweet candy taste-
many times,
but never can I resist again and again.
she is like the apple that was not meant to be eaten,
and so I crave I must keep drinking
from her sweet lips that hide
between her thighs,
and stroke myself in
to keep it warm
as it brews,
for her candy sweet soup
that I indulge in is such a sin.
but the nourishment I gain
from this thirst I hold,
I cannot resist,
she is the temptation that wins...
every time.

Myself as a Poet- You as the Reader

Can I write an interesting poem?
Can I excite my readers with a few words?
Will you have a sentimental unison to my art without feeling like a nerd?
Maybe it's possible while drinking from a Jeroboam.

Readers are wanting more heat in the passion,
They are wanting more enjoyment,
More fulfillment,
They are wanting to see art like the modeling world lives fashion.

I guess this poet has a certain vibe,
A certain way of letting her readers know,
How she wants her career as an artist to grow,
This poet believes she can win the world, there's so many words to transcribe.

This writer wishes to be at the top,
There is so much out there for an artist to do,
Pain, hurt, love, and happiness is a signature into the written brew,
So to the reader: become a fan, I'm not someone you'd want to stop.

The End

This is the end to me.
Why is it that I am
Always the one to lose,
And get hurt?
He says he loves me,
I don't see how.
His hands are rough,
Not calloused,
For they go to
work on Me.
There's a song out
There called,
"Jesus Take The Wheel".
And I now relate
myself to the verses
sung so heart fully.
I feel I am alone,
And there is no one
that understands me,
or my pain.
Jesus, I can't
do this alone
Anymore.
I can't do this by
Myself.
The end of my pain
Is soon to come,
But with that will come
The continuance of my hurt.
For who knows how long?
I will hurt and
I know this...
For I love him.

Nights of Memories

Ageless is the pain,
which come from the memories you gave me.
I can't find my mind;
I am in a mental ward and trying to be found with medication.
"A happy pill",
they tell you it will cure you
but in the end it's just an artificial mask we wear.
Smile to get out,
sing to get the vote of freedom,
and hide to stay out.
People judge wherever you go
so I stay in the shadows with my pain.
One day I will have my own freedom from this mind-
my prison.
These tears are the bars on my bolted shut cell
and this hurt is what cripples me to stay.
I can't escape to safety or shelter,
for my mind goes where I go.
I am so scared in the nights of memory.
Maybe tonight I'll have the strength
to cut that last lifeline out of me-
get it over with.
But I still wonder, what if I can make it through the nights of memories?

Inner Demons

Somewhere I am walking alone,
on a black street, or maybe it's a road.
Who knows where I am at? Who knows where I am going?
On this open walkway, this blackness of hope.

I have these eyes,
and they follow me around.
They are so full of emptiness,
It's such an oxymoron.

Oh those eyes so full of hate,
And I see them when I wake.
I see them all around,
They even stare back at me.

I'm doing my thing,
this free verse thing,
and as I sit here at my laptop,
They slowly turn more visible, just there.

They are red, then they are black,
they have fangs and they have lips.
This evil that lurks in my mirror,
It's really me, my inner demons.

I am slowly rotting, bleeding.
Knowledge is undetermined to fight for life,
And my skin is crawling with itch,
Let me scratch my pain away.

Let me take that final bleed,
Through my teeth I'd rather hiss,
Blow my last breath out through my lips,
And those empty eyes, let them be blinded for the last time.

Inner demons, come out and play.
It's you, me and this blade that will soon be a fade.
Missing you, the silver as it was my friend,
the sharp cut, to unleash my pain.

Yearning for freedom in my world of misery,
I feel the warmth of my own blood,
How I wear it on my lips,
Like theater, it's my mask as my face is now painted.

And my eyes, how distant and empty,
now they are white, and still adolescent empty.
Good heavens, the light is not as I had imagined,
I am enjoying this slip, but it's not fast enough.

How the time is passing,
I can't tell,
Slowly now, my inner demons:
How they said good-bye!

Ended In the Gutter

The pain in my stomach but a mere tease,
of the pain I would be dealing with later.
I have walked for hours and against the cold breeze,
I came to a restaurant and called for my waiter.

He was a lean man with dark, brown hair.
He had a pale face and looked like butter.
He asked me what I was having as I said, "a steak and cooked medium rare".
He came back with a plate, disgusted; it ended in the gutter.

Reality hit me and I knew it was metaphoric.
These butterflies inside were just the waste I had to drop.
This 'boom, boom, splash' catastrophe would be historic.
And the flush of my toilet, hopefully the pipes would not go, "POP!"

CHAPTER 34

Pleading For Help

I am on a constant struggle;
I'm impulsively running into the wall.
I am having lava hot tears flow;
I wish I could hold my childhood doll.

I have a "Chain of Command", that's not really mine,
I'm confused about where I belong in life.
I hear, "At ease soldier! You won't amount to anything."
I am eager to slice recklessly at homicide with a knife.

I am on the verge of a mental meltdown, in the hands of these "animals",
I am in no position even to think about giving up.
I have a family to care about.
I can't afford an "Article 15" but every word that comes out is so abrupt.

I have a strong personality that some find they can't control,
I then get charged in counseling statements, 18 since March.
I have a feeling that I may be in for it, a chapter out discharge,
I am told to stand at attention, as stiff as an ironed shirt with starch.

I am a strong person but a human can only take but so much,
I want to scream and shout and hit everything in sight.
I want to take that M-16 and shoot my way through,
I want to have these "leaders" pay and it is surely their right.

I am on a mental collapse;
I know this is so true.
I am asking for help, but only to the outdoors sky,
I am sorry I feel so, and if I had no family I know I'd be more then blue.

I am at the breaking point,
I'd like so much to take a life,
I'm afraid of myself, I have lost it for the last time.
I need a friend, one that I can confide, losing my mind and full of strife.

I heard this song before, "Jesus Take the Wheel",
I hope He can hear me, because I'm such a damned shit-bag soldier with a loss.
I come to this conclusion, tears streaming down, I can't hold back.
I hold my head to the sky and I now pray, holding a cross.

I don't know who is listening, but I do care.
I thought there were truthful values here.
I guess I was so very wrong for taking this oath.
I ask the Lord, "please guide me, for I have fear, hide me and in the rear.

Mamas Hands

once filled with love and care, always strong,
to hold me above water, never seemed to let me go,
but then came a time where they were always hurtful,
they would touch and they would sadden me, deeper,
and deeper into depression, stronger they became
to hurt, instead of holding me up, now a time,
they hold me down, pushing harder, metal clashing,
chairs being thrown, and prints across the face,
abuse gone wild, abuse gone crazy, never failed a hit,
never missed the target that was their path, only
mama didn't know what would come to be, mama's hands,
they hurt, and in a way that hurt was needed
to feel the love that came with every tear,
every thought of suicide, of death, mama's hands

Falling Tears

I'm looking for me in all places I can
I'm looking for me in places I can't
As I look up to god and I ask for help
I'm looking at the rain
The tears as they run,
It's constantly falling;
These tears of god,
Because what I ask causes so much pain.

It's not the right thing but I'm asking the best I can,
Distances from life and death,
In a moment gone and in a breath,
Looking out into this world,
A drop of rain rolls down my cheek.

These falling tears,
We both let them fall!
I cry inside as the world cries outside.
I know these falling tears,
And His tears that we so call rain.

Everything Happens For A Reason

I got raped the other day
and I was thinkin' of only one thing:
the Lord as I called onto Him
to guide me away.
Back to my house
alive, seven hours it took
as strength loosened my drive for freedom.
And in the minute I was in my house
I shed no tears for the fear I felt.
It passed through my mind
and things got worst
only to find they get worse before they get better.
So yeah, I got raped,
but I'm alive.
I no longer wish as I was wishin' for death.
I will never be a queen,
never for any king.
I am my own self
my own lady,
so as I look forward
to the day ahead
I no longer see that blade of dead.
I'm happier today
and nothin' seems that bad
only because I'm thankful
for that day I just had.
I'm a survivor of rape
and it really doesn't bother me.
I'm no less of a woman,
an actual lady.
I walked myself home
holding my pants

wishing only someone wouldn't recognize me,
for if my nature would ever find out
my nature would say...
"you got what you were lookin' for",
and I know without a doubt
mistakes happen.
Yeah I know
but everything happens for a reason.

A Single Good-bye

As you caressed me, my guidance that was straight made
a turn, no longer on the right, to the left, my mind
took this turn, and now I'm so convinced, wishing you
away from the world in my eyes, you lost your only
hope of love, because I was dedicated, but you hurt me,
and it's being put on stop, my mind shot, already gone
in corrupt, artificial heat I had accepted, now that
love is lost in a world full of fantasy, a daughters
love is rare, hard to find, and you're missing me,
missing the part of you that has died, so continue to
live in motions as reality passes you by, disowning
you, refusing to talk, you not worth a single good-bye.

Pleading With Death

Shinning in my eyes is the silver blade as I die,
running around in circles, my thoughts cease
I say good - bye.
Streaming blood down, I have an energy drain,
tears pouring south, not trying to stop them
or refrain.
Death is a metaphor, unfaithful; she's a whore,
my birth a mistake, according to me.
Goddamned knife please set me free.
Blood as it drips, I'm falling...
just dropping to the floor,
stumbling as I trip, and not giving a fuck.
I don't want to grab on, save me - myself,
with a grip
because this pain that feels so bad,
I'm wishing it was death as my companion.
Pleading with Death, he's absorbing my life,
disgusted with pain, with myself,
I'm using the constant cut, using the knife,
saying good - bye.
I'm through with this life,
cut by cut, blade by blade,
I'll constantly use this pain,
to end my life with my knife.

No Other Way

I'm lost and confused, somehow raped, and abused;
looking forward to that silver drip'
as it warms my body, and lures me away in a lukewarm trip.
I felt the kiss of my blade and then the sex made me fade;
puncturing myself with art so tender
and comfortingly awake.
Suicide, I'm wondering how long You will take,
bayonet strike me and I'm out with a smile.
Left, right, left; blood splatters out in a single file,
kill, kill, kill...
I'm on a constant death struggle,
happily I'll freely ask to have my life taken away, mugged.
Cut, cut, and another cut...
there's no other way,
Suicide, no ifs', ands', or buts'.

Ignorance Is an Illness

Ageless, the beauty of her mind
Ignorance in those that judge, but in her is difference that i find.
Illness only because we are found to be diagnosed, maybe unneeded,
People talk and lies are the meal that they feed it.
Guidelines are not used, throw out and discarded, abused,
Medication day by day, sometimes changed, other times reused.
Misinformed about day to day calculations, and indiscretions; they are confused,
A dictionary given, unasked for, but then refused.
Mental illness a completed diversion to those who must point their finger,
We are looked upon and jailed when we have popped and we wringed her.
So important it is to be educated,
But for they who don't seek the education, why must we be hated?
Inside of our spirits, we hold a secret realm of hope,
Manic-Depression is my battle, ignorance of others no longer hold the rope.
Regulations, and evaluations are a thing of the past,
I had to make them believe I had the power to regain, and I had to do it fast.
So you think you know me, and I will tell you think again and hard,
My emotions are my possessions', and with my life for them I stay on guard.
People judge and we as people don't have the time to walk in the other's shoes,
But double cross me once, disrespect me and you'll be paying your dues.

This Smile Is So Transparent

Laminating a smile over my sadness,
I'm feeling the heat and stress as it is compressed over;
and just like I know, this smile is so transparent.

Feeling a loss like a dagger through my heart,
having a bolt screwed through unwounded flesh;
this agony of hurt bleeding through my eyes.

So I take a cloth and I wipe it away,
no stains or spots as this plastic holds no permanency;
aligning myself with scissors on a blade.

Just allowing it to slide through as it has a sense of ease,
so hold up my feelers and cut them apart;
these feelings of different cannot be sorted.

They too are laminated, as they are also protected,
so tear me apart and you'll see my insides, and what chooses to be hidden;
the sadness, that smile no longer melted on top.

CHAPTER 44

Cataclysmic Tears

These tears that fall from my eyes;
seeming to form a steady flow like high tides of rivers.
A stream appears trickling down my face.
This hurt of tears...Cataclysmic.
A pain numbing precision soaking through my tissue.
And no matter how hard i cry, this pain ceases to stop.
Forcing me to leave my comfort zone.
Trying to find peace and a solution to uncontrolled tears.
How they just don't seem to stop flowing out of my heart.
Justice on my soul for a reliable way to end pain.
But these cataclysmic tears just keep erupting.

CHAPTER 45

The Furnaces Fortune

Its eyes were the color of sin- blood red, darkened black that danced alongside fire. the growling that came from its hungry belly had an appetizing but engorged desire.

not for sweet exasperating sex, nor for the green greed of the rich.

not for human flesh, fresh as night, nor for the tree's wild bark.

pig bones were the furnace's fortune -- made oh so dark.

it had an arctic heart with a subzero limit as powerless as itself without gas -- its main nourishment of a meal. pig squealing came out of the night, the dead die stiff, (as if they'd want to recall), a shy blast of death came as the cold was skeptical to take this life...

(more squealing)
(bones crushing)

death unexamined,

then revealed...

(it's belly now full, for it was fed)

"on high", I say, "pump that heat!"

laying on the couch: my warm, unclothed feet.

CHAPTER 46

Bitchs' Howl

(he is high... and speeding...)

the bitch walked on all fours,
she looked around for her next pussy wedding, emphasizing the itch she had for
becoming a whore,
animal's dicks a delight, how "it" she does adore.

she walks and walks for hours,
seeking the alpha males as they are the deadliest, and full of power,
in her seek she was cornered by her beast and there she cowered.

in that moment she looked into her past realizing she had accomplished nothing
in her pathetic life,
hardship and grievance, full of strife.
she had passed on her diseases like that of wind on a blade of grass, and blood to
a silver knife.

the beast closed in with talons that looked to be made of steel,
slashing and tearing into her bloody bath of a body, the bitch now numb and close
to death could no longer feel,
eyes wide open, this shit was real!

into the night came a distinct sound, an ear piercing screech, the bitch's howl.
as she lay there being eaten alive death came to her followed by her movement of
bowel,
a smell of rotten, shit so foul.

the beast not took her as a victim but as a cycle of life and death.
the prey fall to predators in their final breaths.

(his glass pipe breaks... he's out of meth.)